THE
ART
OF THE
COCKTAIL

Salvatore Calabrese is one of the world's leading bartenders. He has earned a reputation as a bartender with creative style and flair while working at Dukes Bar and The Lanesborough Hotel in London. He has been awarded myriad awards and honours, including both the Chevalier du Champagne and the prestigious Chevalier du Cognac.

Charlotte Trounce is an illustrator living in London. A graduate of the University College Falmouth, she creates personal and distinctive work for clients spanning publishing to product design. Working mostly in paint, Charlotte brings life and colour to the every day, and is inspired by simple objects, people and architecture.

From the Dalí
Wallbanger to the
Stinger Sargent,
cocktails with an
artistic twist

THE
ART
OF THE
COCKTAIL

Foreword by
Salvatore Calabrese

ilex

Contents

Introduction

From Toulouse-Lautrec, who famously carried a draught of absinthe in a hollowed-out walking stick, to Dalí, who threw notoriously raucous surrealist dinner parties, artists of all kinds have been known to enjoy a good drink. *The Art of the Cocktail* captures the artistic spirit in spirits with 50 delicious recipes for art-inspired drinks.

While alcohol might not always have enhanced artists' technical skills, there's no denying that it helped many artists to have some fun along the way – the camaraderie of their drinking coteries in bars and cafes would certainly have kept the creative juices flowing.

At once a compendium of enticing cocktails and a whistle-stop tour through art history, the book will help aspiring mixologists to master the basic principles of cocktail making and then find inspiration for elegant and arty twists on classic themes. So, whether it's with a Pink Ginflatable, a Blue Californian or a Rembrandy Crusta, it's time to raise a glass to your favourite artist and toast their genius.

Foreword

I have always likened the skill of a great bartender to that of an artist at work. The artist has his materials – his paper, his paint – the bartender uses his glass as his canvas to produce his very own work of liquid art.

The feeling, the creativity, even the storytelling are all there. So it is delightful to see drinks and art coming together in a beautiful book that celebrates the art of the cocktail. There are cocktails here that were originally designed in honour of artists and others that are simply inspired by great artists and their work.

Throughout you will find clever and interesting twists on some of our great classic cocktails. The Dalí Wallbanger, for example, is a particular favourite. It reflects so well the colour and mood of the associated artist – based on the Harvey Wallbanger, it is given a surreal twist by a touch of cayenne pepper, which Dalí added to his own cocktail concoctions.

This is a most desirable collection of recipes for any budding mixologist and a lovely book to add to the shelf of an art lover who not only wants to find out more about art, but appreciates a good cocktail too. *Salute!*

Salvatore Calabrese

What is a Measure?

The measure referred to in the recipes is based on a UK bar jigger, which holds 25 millilitres (just under one fluid ounce), and all the spoon measurements are level. If you are using a US bar jigger, which is slightly larger, overfill spoons a little to compensate.

standard UK measure = 25ml
standard US measure = 30ml (1fl oz)
1 level tablespoon = 15ml
1 level teaspoon = 5ml

Unless stated otherwise, the recipes will make enough for one cocktail. They can be scaled up easily as long as the proportions are kept consistent within a drink and the necessary adjustments are made to any spoon measurements. If you are creating cocktails for a number of people, though, bear in mind how much liquid your cocktail shaker can hold.

The Ideal Order

Before you get started, it is worth knowing the basic order of cocktail-making steps that will set you off on the right foot.

1. Chill or warm the glass as required.
2. Prepare any garnish or decoration.
3. Pour the liquid ingredients into the cocktail shaker.
4. Add ice if required.
5. Mix the ingredients using the technique specified.
6. Strain or pour into the prepared glass.
7. Add any garnish or decoration.
8. Serve.

Tools of the Trade

There are all kinds of fancy gadgets available for the would-be mixologist but, unless you are planning to host cocktail parties on a regular basis, only a few must-have items.

Cocktail Shaker

At the heart of the cocktail maker's art, the cocktail shaker is the one accessory you can't do without. There are two kinds: the Boston shaker and the European shaker.

The Boston shaker is used by most professional bartenders. It comes in two parts: a sturdy conical glass and a shaking tin. All the ingredients, including the ice, are added to the tin, then the two parts are pushed together to form a sealed unit before shaking.

The European, or traditional, shaker is the one you're most likely to find on sale and it's also probably a better bet for the novice mixologist. Usually made of metal, it consists of three parts: a conical shaking tin, a strainer and a tight-fitting cap. All the ingredients, including the ice, are added to the tin, then the strainer and the cap are secured in place and away you go.

Strainer

No one wants shards of ice or fruit pips floating round in their cocktail, so many recipes call for straining first. You will need a good eye and a steady hand as you pour the cocktail from shaker to glass. If you're using a European shaker it will have a built-in strainer, but with a Boston shaker you will need a separate one. Bartenders use a Hawthorne strainer – a metal disc with a coiled spring round the edge – but an ordinary tea strainer will do the job. Double- or fine-straining is sometimes recommended to remove every trace of puréed fruit or ice fragments. You could buy a bartender's fine strainer for this but, again, an everyday tea strainer is a perfectly adequate alternative.

Bar Spoon

This is essentially a teaspoon with a very long handle that will reach all the way down to the bottom of the tallest glass. You need one of these for stirred cocktails. Some bar spoons have a twisted handle and a disc-shaped end which can be used when you want to pour in a small amount of liquid to 'sit' on top of a drink. There are a couple of ways of achieving this layering technique (see page 16), so it's not essential to get a bar spoon with a twisted handle.

Measures

Delicious cocktails are all about achieving the right balance of ingredients, so you simply can't do this without measures – or jiggers, as they are sometimes called. These are little metal containers, generally in standard single or double spirit sizes, that allow you to measure out exact amounts of alcohol. For a note on UK and US measures, see page 8.

Muddler

This handy gadget is similar to the pestle part of a pestle and mortar. It's used to bruise fresh mint leaves for a Mojito and to crush fruit, herbs and syrups together at the bottom of a glass before adding the rest of the cocktail ingredients. A wooden one is best.

Peeler or Paring Knife

A citrus peeler or a sharp paring knife is essential for making decorative garnishes.

Ice

You really can't have enough of this, so make sure you prepare plenty in advance, or – easier still – buy a couple of large bags of ready-made ice cubes to store in the freezer. Some cocktails specify crushed or cracked ice. To crush ice, put ice cubes into a strong polythene bag or between two clean tea towels and hit them gently with a rolling pin until they are finely broken. You make cracked ice in a similar way but without breaking the ice so finely.

The Art of the Glass

Most people have a set of wine glasses, a few mismatched tumblers and maybe some champagne flutes in the cupboard. While this is fine for everyday use, it won't do for serving cocktails. A cocktail needs to look fantastic and that means using a superior vessel, so it's worth investing in new glassware before you start measuring out the spirits. Of course, it is very easy to get carried away, so here is a list of different glasses in order of importance, with the last ones reserved for those with serious intent.

Highball/Collins Glass

A highball glass is the 'Jack of all trades' of glassware. Tall, narrow and straight-sided, it can be used for any long cocktail. A Collins glass is slightly taller than a highball, but it's really not necessary to own both.

Rocks/Old Fashioned Glass

A rocks glass is a short, sturdy tumbler, ideal for straight spirits and muddled drinks such as the Mojito. Although it often goes by the same name, a traditional Old Fashioned glass is slightly bigger; in fact it's sometimes called a double rocks glass.

Martini Glass

This is the classic cocktail glass, but can be used for so much more than just Martinis. With its distinctive triangular shape and delicate stem, it's sophisticated enough to play host to the most extravagant drinks in your repertoire.

Champagne Flute

The long, elegant lines of a flute help to keep the bubbles intact in sparkling drinks, hence the natural pairing with champagne.

Margarita Glass

If you know you'll be serving Margaritas it's worth investing in the right glass to show the drink at its best. The rim of the Margarita glass just cries out for frosting. Daiquiris and other drinks with fruit garnishes also suit being served in this curvaceous glass.

Shot Glass

These are used for quick-hit drinks, which can be simple single or double servings of spirits or carefully layered creations.

Balloon Glass/Snifter

If you're having the kind of party where elders in tweed stand around by the fire cradling a Scotch, then move this glass up the list. If not, you can probably survive without it. The bowl shape is designed for warming the drink, which makes it a good partner for a brandy snifter.

Coupe/Champagne Saucer

The coupe or champagne saucer is perfect for serving straight-up (without ice) drinks.

Hurricane Glass

Not much seen these days, apart from in the beach bars of holiday resorts, this glass resembles a hurricane lamp. It is most frequently used to serve long, creamy cocktails.

Nick & Nora

A dainty, thin-stemmed glass, named after the husband and wife detective team in Dashiell Hammett's classic detective story *The Thin Man* (1934). Slightly smaller than a coupe, this glass nevertheless suits the same kinds of drinks that would usually be served in one and evokes the post-Prohibition Golden Age of Hollywood.

Techniques & Terms

If you want your cocktails to taste as good as those made by prize-winning mixologists you will have to master a few techniques and understand a few terms. Each type of drink is prepared differently, in order to mix the ingredients together perfectly and achieve the best possible flavour.

Ideally, glasses should be chilled in a freezer for about 20–30 minutes prior to use. If this isn't possible fill them with crushed ice, then discard it before pouring your cocktails.

Shaking

The art of mixing and chilling a cocktail in one action. All the ingredients are added to a cocktail shaker along with ice and shaken vigorously. As well as chilling the drink, the ice acts as a beater in the shaker.

This is fairly simple but you will need a strong wrist to really combine the ingredients and ensure that the cocktail is well chilled.

1. Half-fill the cocktail shaker with ice cubes, cracked ice or crushed ice (depending on the recipe).
2. Chill the glass.
3. Add the ingredients to the shaker, seal with the cap or the other half of the shaker (depending on the style of shaker) and shake until there's frost – condensation – on the outside of the shaker.
4. Strain the drink into the glass.

Stirring

As a general rule, cocktails with transparent ingredients are stirred rather than shaken, as vigorous shaking would spoil the drink's clarity.

This requires a gentle touch and is used for drinks that need to be chilled but remain clear.

1. Add the ingredients to the cocktail glass or a separate mixing glass.
2. Use a bar spoon to lightly stir the ingredients together. Sometimes ice is included, to chill the drink at the same time.
3. If using a mixing glass pour the drink into the cocktail glass.

Muddling

A technique in which you use a blunt tool, known as a muddler (*see page 11*), to mash fruits, herbs and syrups together at the bottom of a glass.

The Mojito is probably the best-known muddled drink, although there are others that are also prepared in this way.

1. Pull the mint leaves from the stems and place them at the base of a highball glass.
2. Add sugar syrup (*see page 23*) and lime wedges.
3. Use the muddler to push down on the ingredients for about 30 seconds, extracting as much juice and flavour as possible.
4. Top up the glass with crushed ice before adding the spirit and mixer, according to the recipe.

Layering

This is a clever technique often used in shots. The heaviest liquid is added to the glass first, followed by the remaining ingredients, one by one, to create multicoloured layers. There are two ways of achieving this effect:

Option 1

1. Add the first ingredient, as listed in the recipe, pouring it carefully into the centre of the glass.
2. Place a twisted-handle bar spoon in the centre of the glass, holding the flat disc-shaped end over the surface of the drink, and slowly pour the second liquid onto the top of the spoon. The second liquid will gradually and evenly run down the spoon until it sits on the surface of the first.
3. When you've finished all the layers, remove the spoon and serve.

Option 2

1. Add the first ingredient, as listed in the recipe, pouring it carefully into the centre of the glass.
2. Gently pour the second liquid over the back of a spoon (this can be the bowl end of a bar spoon or a soup spoon), making sure that the spoon is touching the inside of the glass and is in contact with the drink.

Blend

It is sometimes necessary to blend a cocktail that uses fresh fruit and/or crushed or cracked ice. Put your ingredients into a blender or liquidizer and blend for about 20-30 seconds. Never add carbonated liquids to a blender, as the mixture might explode.

Build

A term used to describe the simplest cocktail-making process, in which you fill the glass with ice and pour over the ingredients, in the correct order and proportions, then serve.

Dash

A very small amount of an ingredient added to a cocktail, it is usually used to refer to items with a very strong flavour, such as syrups, bitters and sauces. A dash is about 5ml (1 teaspoon).

Float

To form a separate layer of liquid on top of a denser liquid ingredient in a drink.

Frosting

An effect achieved by coating the rim of a cocktail glass, usually with sugar or salt (see page 18).

Spiral

A decoration made by cutting a long strip of rind from a citrus fruit and winding it round a cylindrical object, such as a straw, to give it a spiral shape. As well as being decorative, the rind can also impart extra flavour to a drink (see page 20).

Straight Up

A drink served without ice.

Strain

After a cocktail has been shaken or stirred, it is often strained to remove ice and fruit fragments. Cocktails that must be served absolutely clear require double- or fine-straining (see page 10).

Twist

A long piece of pared fruit rind, usually from citrus fruit, which is added to a drink to release the oils and impart flavour.

Decorative Touches

Once you've chosen the right glass, measured the spirits accurately, shaken or stirred, then poured out the cocktail without spilling a drop, it's time to add the finishing touches to your masterpiece. Many cocktails demand decorations or garnishes, giving you a chance to show off your artistic side by manipulating fruit or frosting glasses. Here are a few ideas to impress your guests.

Frosting

Some cocktails, such as the Margarita, require the glass to be frosted as part of the recipe, while others can be frosted purely for decoration. You can use salt, sugar or even cocoa powder, and it's an easy technique to perfect.

1. Put some lemon or lime juice into one saucer and some salt or sugar into another. If you are using cocoa powder or another substance that doesn't go with citrus juice, you can use water or a small splash of any liqueur used in the cocktail.
2. Dip the rim of the glass first into the liquid, then into the frosting ingredient, twisting it round for even coverage.
3. Clean excess frosting from the inside of the glass using a lime or lemon wedge.
4. Carefully pour the drink into the centre of the glass so that the frosting remains intact.

Citrus Twists

These twists are for flavour as well as for aesthetics. Some recipes call for a twist of orange or lemon rind to be added at the end. Others may ask you to squeeze the rind over the drink before the twist is added so as to express the citrus oils.

1. Using a peeler or paring knife, cut a wide strip of rind from the fruit and remove all traces of pith.
2. Give the rind a quick twist over the drink to release the aromas and then float it on top or balance it on the rim of the glass.

Citrus Fruit Wedges

Wedges are the classic cocktail accompaniment and any citrus fruit will work. Sometimes the drink will call for a particular wedge, but otherwise use your discretion. Remember, though, that less is more: if you can't get to the drink for a forest of fruit, you've probably taken the decoration a step too far. You can either float the wedge in the drink or make a nick in the edge of the fruit and slip it over the rim of the glass.

Wheels and Slices

Neat, thin, circular cross-sections of citrus fruit or delicate slices of other fruit make beautiful garnishes. You can float them on the surface of the drink itself or cut through to the middle of the wheel or slice, then slot them onto the rim of the glass so that they sit upright.

Spirals

Made from citrus fruit or cucumber, spirals require a little more attention than wedges or wheels, but they look impressive and you can always make a batch in advance.

1. Using a peeler or paring knife, cut a long, even strip of rind from a citrus fruit or peel from a cucumber, then wind it carefully round a straw or a bar spoon.
2. Wait a minute or two for the spiral shape to set, then slide it off and place in the drink.

Swizzles and Fruit Kebabs

You can have great fun with cocktail-stick decorations, which look fabulous. For a simple swizzle, just impale a single cocktail onion, olive or maraschino cherry on a stick – ideal for elegant sipping. For more exciting creations, thread any small fruit you like (blueberries, cranberries, strawberries...) on to a cocktail stick, like a kebab, then balance on the rim of the glass to finish off the drink in style.

Stocking Your Bar

When it's time to stock up your bar, think about what you're actually going to use. If you're throwing a cocktail party, it's best to choose a select list of cocktails to offer your guests, unless you want to spend a fortune. Certain key spirits, mixers and garnishes are used in many different drinks, so work out your menu and shop accordingly.

Base Spirits

There are numerous spirits, liqueurs and other alcoholic drinks used in the cocktails in this book, from chartreuse to vermouth, from cider to prosecco, but you don't have to keep all of them in stock all of the time. Check what you are going to need well before you plan to serve your cocktails. The following are the most commonly used spirits:

Gin

This is essential as it features in so many different cocktails. It's no coincidence that the gin and tonic is probably the most popular cocktail in the world, and one of the simplest to make.

Vodka

Another widely used cocktail base, this flavour-free spirit is incredibly versatile and can be combined with virtually any mixer.

Rum

Rum brings an exotic flavour to any drink. Some cocktails call for light rum and others for dark, so check the ingredients before you hit the shops.

Tequila

The famous Mexican export is probably best known for its use in the Margarita. Though not for the faint-hearted, this ancient spirit should definitely be on the mixologist's list.

Whisky

The origins of this spirit are hotly contested, with both Scotland and Ireland staking a claim. You can spend a lot of money on a bottle of whisky, so if you're going for top quality, save it for sipping; for cocktails, put your money somewhere in the middle.

Brandy

With its strong and distinctive flavour, brandy forms the base of many cocktails. A good-quality cognac (VSOP or better) is essential for the finest. There are plenty of different fruit brandies available – make sure you have at least one bottle in your bar.

Mixers and Garnishes

Although spirits are the stars of the cocktail world, they would fail to shine if it weren't for the presence of mixers. The same holds true for garnishes, because some cocktails simply don't work without the essential maraschino cherry or citrus twist. Depending on the recipes you're going to make, ensure that you stock up on the following:

cola

ginger beer

ginger ale

lemonade

soda water

tonic water

fresh lemons, limes and oranges
 (useful for both juicing and
 decoration)

a good selection of fruit juices
 (e.g. orange, apple, grapefruit,
 cranberry, pineapple)

fruit syrups
 (e.g. grenadine, passion fruit,
 blackcurrant)

sugar syrup
 (see opposite)

elderflower cordial

Angostura bitters

Tabasco sauce

Worcestershire sauce

green olives

maraschino cherries

fresh mint leaves

nutmeg for grating

rock salt

granulated, caster and
 demerara sugar

coconut cream

eggs

single cream

straws

cocktail sticks

drink swizzles

Sugar Syrup

If you're taking your new role of mixologist seriously, then you should definitely have a batch of sugar syrup to hand. This simple blend of sugar and water is what's used to sweeten cocktails because it blends into a cold drink faster than ordinary sugar and gives the cocktail body. Basic sugar syrup is available ready-made and there is also a wide selection of fruit syrups on the market, but it's very easy to make your own. Here's how:

Makes 60ml (2 fl oz)
4 tablespoons granulated sugar
4 tablespoons water

Put the sugar and water into a small saucepan and bring slowly to the boil over a medium heat, stirring with a wooden spoon to dissolve the sugar. Boil without stirring for 1–2 minutes, then leave to cool. The syrup can be stored in a sealed, sterilized jar or bottle in the refrigerator for up to 2 months.

The Recipes

Dalí Wallbanger

6 ice cubes
1 measure vodka
3 measures fresh
 orange juice
1–2 teaspoons Galliano
pinch of cayenne pepper
orange wheels and
 maraschino cherry,
 to garnish

The original Harvey Wallbanger cocktail was named after a Californian surfer in the 1960s, who drank so many of this cocktail that he banged off the bar walls on his way out. This version adds a twist with a pinch of cayenne pepper – an ingredient featured in a cocktail recipe for the Casanova Cocktail created by Salvador Dalí himself in his 1973 recipe book *Les Dîners de Gala*. In the wisdom of the surrealist, this cocktail is 'quite appropriate when circumstances such as exhaustion, overwork or simply excess of sobriety are calling for a pick-me-up'.

Put half the ice cubes into a cocktail shaker and the remainder into a highball glass. Add the vodka and orange juice to the shaker and shake until a frost forms on the outside of the shaker. Strain over the ice in the glass. Float the Galliano on top. Decorate with a pinch of cayenne pepper, orange wheels and a maraschino cherry, and serve.

Cézanne's Fruit Bowl

4–5 ice cubes
2½ measures vodka
2 measures
 pomegranate juice
1 tablespoon grenadine
orange rind twist, to garnish

The Post-Impressionist painter Paul Cézanne was fascinated by the shape and texture of the pomegranate and a number of his still lifes feature the jewel-like fruit. Pomegranates are the main ingredient in grenadine, a non-alcoholic syrup used in many cocktails. As well as imparting a lovely rich colour to drinks, it adds a fruity flavour.

Put the ice cubes into a cocktail shaker. Pour the vodka, pomegranate juice and grenadine over the ice, then shake until a frost forms on the outside of the shaker. Strain and pour into a rocks glass. Garnish with the orange rind twist and serve.

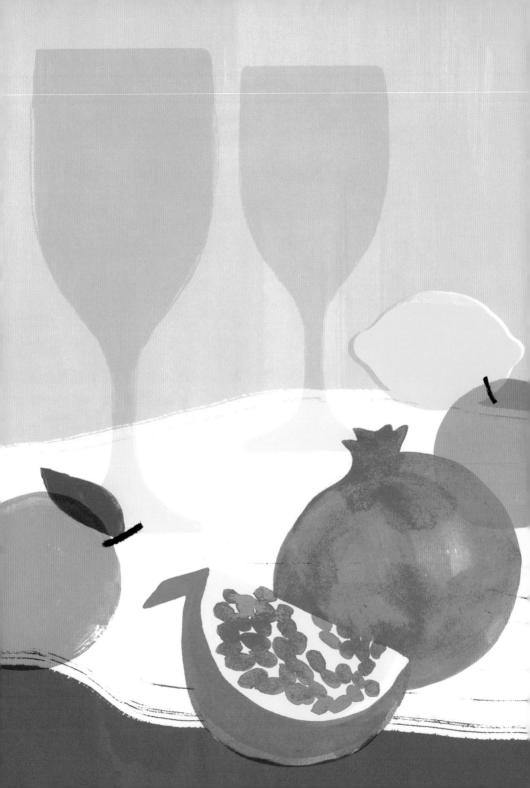

The Gauguin

3 measures crushed ice
2 measures white rum
1 measure passion
 fruit syrup
1 measure lemon juice
½ measure lime juice
maraschino cherry,
 to garnish

This traditional fruit cocktail was inspired by Post-Impressionist artist Paul Gauguin, who spent the last ten years of his life living and working in French Polynesia. The spirit in this drink is white rum – a light rum, distilled from sugarcane juice and molasses. The passion fruit syrup and citrus lend it a delicious tropical taste, conjuring up images of Tahiti.

Put the crushed ice, rum, syrup and fruit juices into a blender and blend until smooth, then pour into a hurricane glass. Add the maraschino cherry and serve.

Blue Moon

5–6 ice cubes, cracked
1 measure vodka
1 measure tequila
1 measure blue Curaçao
lemonade, to top up

French artist Yves Klein was famously said to have declared 'the blue sky is my first artwork', signing the sky and claiming it as his own. The colour blue recurs in much of his work. He went on to develop a paint pigment he named 'International Klein Blue' in collaboration with Edouard Adam, a Parisian art paint supplier, and which he registered as a trademark colour in 1957. A classic Blue Moon cocktail pays tribute to the artist's love of the colour.

Put half the cracked ice into a mixing glass. Add the vodka, tequila and blue Curaçao and stir to mix. Put the remaining ice into a tall glass and strain in the cocktail. Top up with lemonade and serve with a straw.

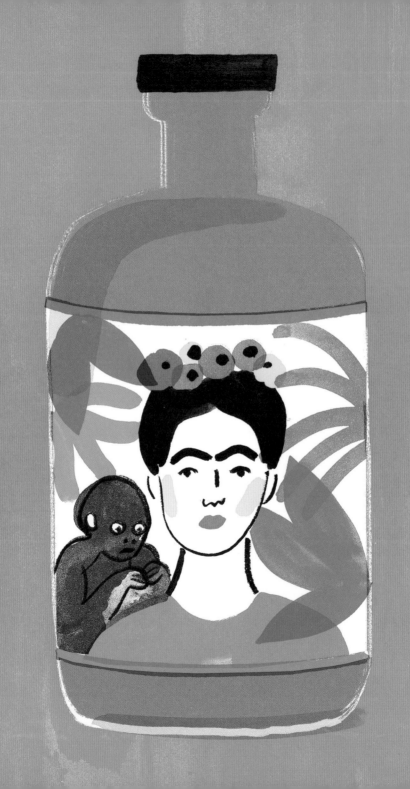

Cantina Coffee

6 ice cubes
2 measures Kahlúa
1 measure lemon juice
½ measure sugar syrup
 (see page 23)
1 egg white
lemon slice, to garnish

Frida Kahlo was deeply proud of her Mexican heritage and her paintings are full of national symbolism. In a letter to her friend Antonio Rodríguez in 1952, she wrote, 'I wish to be worthy, with my paintings, of the people to whom I belong and to the ideas which strengthen me.' Dark, piquant and strong, this classic sour cocktail, laced with the country's famous coffee liqueur, honours the roots of Mexico's most celebrated artist.

Put 2 ice cubes into a cocktail shaker and another 2 into a chilled rocks glass. Pour the Kahlúa, lemon juice, sugar syrup and egg white into the shaker. Shake for about 10 seconds, then add the remaining ice cubes and shake again for another 10 seconds. Strain into the glass over the ice, garnish with the lemon slice and serve.

Pow!

2 measures blended Scotch
1 measure sweet vermouth
2 dashes Angostura bitters
4–5 ice cubes
maraschino cherry, to garnish

Bold, bright and brash, Roy Lichtenstein's tongue-in-cheek damsels in distress and comic-book style perfectly captured the rebellious spirit of the 1960s, and were seen as borderline heretical by many art critics of the time. His explosive freeze-frames, inspired by popular war comics, certainly packed a punch, much like the Rob Roy cocktail on which this drink is based. You don't have to use the best Scotch; in fact it's the mid-range brands that work best here – a detail that would have pleased the popular parodist.

Combine all the ingredients in a mixing glass and stir until well chilled. Strain into a chilled Martini glass and serve with the maraschino cherry, which can be threaded onto a cocktail stick if desired.

Riviera Breeze

4–5 ice cubes
2 measures vodka
4 measures cranberry juice
2 measures fresh pink
 grapefruit juice
2 lime wedges

The Fauvist artist Raoul Dufy brought the Mediterranean vividly to life in his joyful canvases. With hundreds of oil paintings of yacht regattas and beachgoers, and a preoccupation with the view of Nice's Baie des Anges, his works are so associated with the French Riviera that they now adorn many a postcard. Picture yourself beside the brilliant blue sea of Dufy's Côte d'Azur and serve up this refreshing Sea Breeze cocktail, with its bracing combination of cranberry and grapefruit juices. To further evoke the spumy seaside experience, you could even shake it up in a cocktail shaker for a foamy surface.

Put the ice cubes into a highball or hurricane glass. Pour over the vodka and fruit juices. Squeeze the lime wedges into the drink and stir lightly before serving.

Pink Ginflatable

1–4 dashes Angostura
 bitters
1 measure gin
iced water, to top up

Jeff Koons's vinyl inflatables, liquor-themed magazine-ad paintings and monumental stainless-steel sculptures have attracted controversy and accolades in equal measure across the art world. Those reflective mirror-shine surfaces are designed to encourage introspection, reminding the viewer of their own existence; as Koons says 'It's all about you'. Inspired by the luxurious pinks of Koons's magenta inflatables, find yourself with this classic Pink Gin. The Angostura bitters give the cocktail its seductive pink tone.

Shake the bitters into a Martini glass and swirl around to coat the inside of the glass. Add the gin and top up with iced water to taste, then serve.

René Martini

ice cubes
2 measures vodka
1 measure apple schnapps
1 tablespoon apple purée
1 dash freshly squeezed
 lime juice
a pinch of ground cinnamon
green apple slice, cut
 vertically through the
 centre of the apple, pips
 discarded, to garnish

René Magritte would have said, 'This is not an Apple Martini', and he would have been right – because it's a *recipe* for an Apple Martini. The green apple was a recurring motif in Magritte's work. Inspired by *The Son of Man* (1964), this cocktail is garnished with a whole green apple slice to evoke his Surrealist vision. Don't drink too many or you may find yourself doubting the nature of your own existence.

Half-fill a cocktail shaker with ice cubes. Add the vodka, apple schnapps, lime juice and cinnamon and shake until a frost forms on the outside of the shaker. Fine- or double-strain into a chilled Martini glass. Float the green apple slice on top and serve immediately.

Between the Crumpled Sheets

ice cubes
½ measure brandy
½ measure white rum
½ measure Cointreau
1 measure fresh
 orange juice
orange rind spiral, to garnish

When Tate Britain exhibited 'enfant terrible' Tracey Emin's *My Bed* (1998) as a shortlisted work for the 1999 Turner Prize, the confessional and deeply personal detritus-strewn tangle of bedsheets catapulted Emin to international stardom. She's been known to nap at parties, pulling up a couple of chairs and taking a quick snooze in the thick of it, before carrying on with the fun. In her own words, 'I can catnap anywhere and at any time ... the key is not to get embarrassed.' A spiky orange Between the Sheets cocktail packs a powerful punch – the ideal drink for those who don't shy away from anything.

Half-fill a cocktail shaker with ice cubes. Add the brandy, rum, Cointreau and orange juice and shake briefly to mix. Strain into a chilled Martini glass. Garnish with the orange rind spiral and serve.

Blue Californian

3 measures crushed ice
1 measure white rum
½ measure blue Curaçao
2 measures pineapple juice
1 measure coconut cream
pineapple slice, to garnish

The vivid colours of David Hockney's world spring not from his Bradford beginnings but from the glamour, light and heat of Los Angeles – the place he made his home for four decades and, in his words, 'the land of swimming pools'. Dive headfirst into summer and mix up this tropical Blue Hawaiian cocktail, also known as the Swimming Pool, the vivid colour of which brings to mind Hockney's glittering poolscapes.

Put the crushed ice into a blender. Add the rum, Curaçao, pineapple juice and coconut cream and blend on high speed for 20–30 seconds, then pour into a chilled hurricane glass. Garnish with the pineapple slice and serve.

Spray Can Sidecar

ice cubes
1 measure Cointreau
2 measures brandy
1 measure fresh lemon juice
orange rind spiral, to garnish

Jean-Michel Basquiat's pithy satirical comments about broken America and the art scene, graffitied on the walls of downtown New York in the late 1970s with the famous SAMO tag, are what first brought him to the art world's notice. Before long, the paint-splattered Armani-suited wild child became a sell-out success, but he never lost his caustic edge. A cocktail to celebrate Basquiat ought to have a sharp taste to match his sharp wit. This tart Sidecar is a classic cocktail that offers this in abundance.

Half-fill a cocktail shaker with ice cubes. Add the Cointreau, brandy and lemon juice, and shake until a frost forms on the outside of the shaker. Strain into a chilled Martini glass. Garnish with an orange rind spiral and serve.

Henry Mojito

12 fresh mint leaves, plus an
 extra sprig, to garnish
½ measure sugar syrup
 (see page 23)
4 lime wedges
crushed ice
2 measures white rum
soda water, to top up

Inspired by the natural world, Henry Moore's compelling organic forms draw analogies between the human body and the landscape, and the sculptor returned often to the motif of the reclining figure. The Mojito, the classic muddled cocktail, similarly lets the natural world take centre stage in its composition, filled with the freshest mint. Place the extra mint sprig near your straw, so that you get a whiff of its herbal fragrance every time you take a sip, then lie back and enjoy.

Put the mint leaves, sugar syrup and lime wedges into a highball glass and muddle together. Fill the glass with crushed ice, pour over the rum and stir. Top up with soda water. Garnish with the mint sprig and serve with a straw.

Muralist's Margarita

lime wedge

rock salt

ice cubes

2 measures tequila

1 measure fresh lime juice

1 measure triple sec

lime wheel, to garnish

Diego Rivera was one of Mexico's most prominent painters, known for his socialist frescoes and murals, and as a fervent chronicler of his country's history. He was also, famously, husband to Frida Kahlo (see page 34). A rather mismatched couple, they had a tumultuous relationship; Frida's parents called them 'the elephant and the dove'. Their local watering hole was the Cantina La Guadalupana, where the pair would drink Mexico's spirit of choice, tequila, the key ingredient in this classic Margarita recipe.

Moisten the rim of a Margarita glass with the lime wedge and frost with the salt. Half-fill a cocktail shaker with ice cubes. Add the tequila, lime juice and triple sec and shake until a frost forms on the outside of the shaker. Strain into the glass, garnish with the lime wheel and serve.

Pablo Pisco Sour

ice cubes
2 measures Pisco
1 measure fresh lemon juice
1 dash absinthe
2 teaspoons caster sugar
1 egg white
1 dash Angostura bitters

First created in the early 1900s, the Pisco Sour came about to render Pisco grape brandy more drinkable with a simple sweet and sour mix. This version includes a dash of absinthe, the bitter green hallucinatory spirit that featured prominently in the lives of Pablo Picasso and his circle of friends. The young Picasso painted several haunting images of absinthe drinkers, and cast and hand-painted six Cubist bronzes entitled *Glass of Absinthe* in 1914. At the time, the French government was debating whether to ban the drink, and did so the following year. Perhaps the sculptures were an act of artistic defiance or maybe they were a bohemian's farewell.

Half-fill a cocktail shaker and fill a rocks glass with ice cubes. Add the Pisco, lemon juice, absinthe, sugar and egg white to the shaker and shake until a frost forms on the outside. Strain over the ice in the glass. Add the bitters to the drink's frothy head and serve.

Duchampagne 75

cracked ice
1 measure gin
juice of ½ lemon
1 teaspoon caster sugar
chilled rosé champagne
 or sparkling rosé wine,
 to top up
fresh rose petal, to garnish

French-American artist Marcel Duchamp created experimental conceptual pieces and became famous for his 'readymades', such as his signed urinal, *Fountain*, exhibited in 1917, which shocked the genteel New York art world of the time. He also created a mysterious female alter ego, Rrose Sélavy, which sounds like the French phrase *Eros, c'est la vie* or even *arroser la vie* ('love is life' or 'to make a toast to life'). This twist on the French 75 cocktail, with its effervescent fusion of gin and rosé champagne, is the ideal drink with which to make your own toast to love, or life, or both.

Half-fill a highball glass with cracked ice. Add the gin, lemon juice and sugar and stir well. Top up with chilled rosé champagne or sparkling rosé wine. Garnish with the rose petal and serve.

Blackest Black Russian

4–6 ice cubes, cracked
2½ measures vodka
1 measure Kahlúa
chocolate stick, to garnish
 (optional)

Vantablack is the blackest black there is, which means that when you look at something coated in it you see only a void. Originally developed by engineers for the aerospace industry, the contemporary sculptor Anish Kapoor, whose work explores the complex relationships between form, space and perception – often using negative space and voids – owns the exclusive rights to use the colour artistically. The Black Russian cocktail dates back to 1949 and can be served short or long, topped up with chilled cola. It will never be as black as Vantablack, but it will deliciously fill a void.

Put the cracked ice into a rocks glass. Pour over the vodka and Kahlúa and stir. Garnish with a chocolate stick, if you like, and serve.

American Beauty

4–5 ice cubes
1 measure brandy
1 measure dry vermouth
1 measure fresh
 orange juice
1 measure grenadine
1 dash white crème
 de menthe
2–3 dashes ruby port
maraschino cherries,
 mint sprig and orange
 rind spiral, to garnish

Georgia O'Keeffe's wild New Mexico landscapes have become synonymous with her work. Santa Fe, with its dramatic desert expanses and rocky outcrops, was the place she would eventually call home and the astonishing colours she coaxed out of the mountains and skies have become iconic images of American landscape art. Inspired by her 'rust red hills', the ruby port in an American Beauty gives this drink a distinctive dark red colour. So, sit back and imagine yourself there, enjoying the breathtaking beauty of a Santa Fe sunset.

Put the ice cubes into a cocktail shaker. Add the brandy, vermouth, orange juice, grenadine and crème de menthe and shake until a frost forms on the outside of the shaker. Strain into a Martini glass. Tilt the glass and gently pour in the port so it floats on top. Garnish with the maraschino cherries, mint sprig and orange rind spiral, then serve.

Dark & Stormy

4–5 ice cubes

2 lime wedges

2 measures dark rum

3 measures ginger beer

J. M. W. Turner loved a shipwreck, returning often to the themes of violent storms, turbulent seas and burning boats. The destructive power of nature held a fascination for him, and it certainly worked with his distinctive style of dramatic colour washes that created ephemeral atmospheric effects. Contemplate those foaming waves and roiling cloudscapes over a Dark & Stormy – the highball cocktail of dark rum mixed with effervescent ginger beer served over ice.

Put the ice cubes into a highball or collins glass and squeeze one of the lime wedges over the ice. Pour over the rum, then top up with ginger beer and stir briefly. Serve topped with the other lime wedge.

B-Movie Belle

½ measure cherry liqueur
½ measure Amaretto di
 Saronno
½ measure bourbon
 whiskey

In Cindy Sherman's famous series *Untitled Film Stills*, the groundbreaking artist recreated every clichéed image of the Hollywood B-movie starlet (ingénue, lonely housewife, working girl, vamp), transforming herself with make-up and costume for each of the 70 black-and-white shots. This cocktail, based on the American Belle, is sweet and rich with bourbon and cherry liqueur, yet multi-layered, and gives a tongue-in-cheek nod to those idealised pin-ups that Sherman parodied.

Pour the cherry liqueur into a shot glass. Using the back of a bar spoon, slowly float the Amaretto over the cherry liqueur *(see page 16)*. Pour the bourbon over the Amaretto in the same way and serve.

The Perry

1 sugar cube
1–2 dashes Angostura
 bitters
1 measure pear brandy
4 measures well-chilled
 perry or pear cider
pear slice, to garnish

Grayson Perry is a Renaissance man – a Turner Prize-winning artist, documentary maker, author and commentator on contemporary life – who uses traditional craft techniques such as pottery, collage and tapestry to deliver strikingly modern ideas. If Grayson is an artist reviving old practices, his namesake, perry, is a drink doing the same. Traditionally hailing from the farms of Britain and northern France, perry is made exclusively from perry pears. At a push, although it's not quite the same, pear cider is an acceptable substitute. This is a pear-flavoured riff on the classic Champagne Cocktail, with dry sparkling perry in place of the traditional bubbles.

Put the sugar cube into a chilled Martini glass or champagne flute and saturate with the bitters. Add the pear brandy, then top up with the chilled perry or cider. Garnish with the pear slice and serve.

Flower Power Sour

ice cubes

1½ measures Absolut
Mandarin Vodka

½ measure Mandarine
Napoléon liqueur

2 teaspoons elderflower
cordial

2 teaspoons sugar syrup
(see page 23)

1 measure fresh lemon juice

orange rind spiral, to garnish

Most artists have their recurring motifs and Vincent van Gogh returned several times to the sunflowers that would posthumously come to define him. In one of his letters to his brother Theo he wrote, 'Jeannin has the peony, Quost has the hollyhock, but I have the sunflower...' This unusual, fresh and fragrant Sour brings to mind Van Gogh's daring spectrum of yellows and oranges with mandarin-infused spirits and elderflower cordial.

Half-fill a cocktail shaker and fill a rocks glass with ice cubes. Add the vodka, liqueur, elderflower cordial, sugar syrup and lemon juice to the shaker and shake until a frost forms on the outside. Strain over the ice in the glass. Garnish with the orange rind spiral and serve.

Manhattan Nighthawk

4–5 ice cubes
2 measures rye whiskey
 or bourbon
1 measure extra dry
 vermouth
4 dashes Angostura bitters
maraschino cherry,
 to garnish

Edward Hopper's brightly lit downtown diner in *Nighthawks* (1942) is one of the most recognizable scenes in American art, but no one has ever been able to pinpoint the exact location of the restaurant that inspired it. It's a moody and disenchanted scene, but it could have been so different if only they'd replaced their mugs of coffee with a Manhattan or two. This vintage cocktail was reputedly created at New York's Manhattan Club, although other reports place its origins elsewhere in the borough. Regardless, it was undoubtedly made somewhere in the vicinity of Hopper's mysterious Greenwich Village hangout.

Put the ice cubes into a mixing glass, then add the whiskey (or bourbon), vermouth and bitters and stir. Strain into a chilled Martini glass, garnish with the maraschino cherry and serve.

Hair Raiser

1–2 ice cubes, cracked
1 measure vodka
1 measure sweet vermouth
1 measure tonic water
lemon and lime rind spirals,
 to garnish

A Surrealist well before her time, at just fifteen years old Dorothea Tanning painted a naked women with leaves for hair and in so doing horrified her family. Undeterred, she went on to have a seven-decade artistic career, during which she pushed the boundaries of the genre and delighted in the enigmatic and the perverse. Inspired by one of her most famous works, *Eine Kleine Nachtmusik* (1943), an unsettling scene featuring a little girl with hair streaming upwards, this Hair Raiser cocktail's combination of vodka and vermouth is simple but deliciously exhilarating.

Put the cracked ice into a highball glass. Pour over the vodka, vermouth and tonic water and stir lightly. Garnish with the lemon and lime spirals and serve.

Wassail Kandinsky

Makes 4–6 servings

1 litre (1¾ pints) cider
250g (9oz) demerara sugar
1 cinnamon stick
a pinch of ground cloves
a pinch of grated nutmeg
8 measures brandy
4 baked apples
4–6 lemon slices

For Wassily Kandinsky, music, emotion, line and colour were all inextricably linked. Each note he heard, each emotion he felt, was transposed into a symphony of unique marks and hues on his canvas. That music is everywhere in his paintings is attributed by some to synaesthesia, for it is said that Kandinsky saw colours when he heard music. Wassail – a winter punch traditionally served to wassailers, or carol singers – is certainly a warming composition and this one will keep musically minded revellers very happy.

In a large saucepan, bring half the cider to the boil, along with the sugar and spices, stirring from time to time. Add the remaining cider and the brandy, then pour into a warmed punch bowl. Add the baked apples and lemon slices and serve hot, ladled into tumblers.

Stinger Sargent

crushed ice
2½ measures Cognac
1 measure white crème
 de menthe
mint sprig, to garnish

The Stinger was a cocktail invented around 1890, which makes it a contemporary of John Singer Sargent, the prolific portrait painter. Sargent painted many distinguished members of Edwardian society, including, famously, the actress Ellen Terry. His *Ellen Terry as Lady Macbeth* (1889) shows her in a shimmering emerald-green dress decorated with iridescent beetle wings. The idea was to create the effect of a serpent's scales – the trappings of glamour hiding Lady Macbeth's insidious nature – and the portrait caused quite a stir. In a Stinger, the peppermint flavour of the crème de menthe was said to have masked the 'sting' of an inferior brandy, so it is an apt reminder of that artistic conceit.

Half fill a mixing glass with crushed ice and add the Cognac and crème de menthe. Stir, then strain into a rocks glass half-filled with more crushed ice. Serve topped with the mint sprig.

Perfect Composition

½ measure dry vermouth
3 measures ice-cold gin
green olive or lemon rind
twist, to garnish

Over the course of a career in search of the universal truth in objects, Piet Mondrian eventually restricted himself to working with only horizontal and vertical straight lines, black on white, and the basic primary colours. His compositions were not symmetrical but could scarcely be purer in their elements. A cocktail that celebrates this master of restraint needs to be equally uncomplicated. How about the most famous of them all, a classic Dry Martini? Just three elements – perfection in simplicity.

Swirl the vermouth round the inside of a chilled Martini glass, then discard the excess. Pour in the ice-cold gin and add the olive or lemon rind twist to serve.

Green Mule

3–4 ice cubes, cracked
2 measures green
 chartreuse
juice of 2 limes
ginger beer, to top up
lime wheel, to garnish

While gaudy circus performers frolic, lovers fly through the air and animals appear in all colours of the rainbow, Marc Chagall's works are simultaneously filled with images firmly rooted in the real world, particularly his native Russia. Chagall spent part of his life in an artists' colony near Paris, but remained nostalgic for his homeland. Inspired by his painting *The Green Donkey* (1911), this cocktail uses the green herbal spirit chartreuse in place of the traditional vodka for a magical twist on the classic Moscow Mule.

Put the cracked ice into a cocktail shaker. Add the chartreuse and lime juice and shake until a frost forms on the outside of the shaker. Pour, without straining, into a highball glass, top up with ginger beer and stir lightly. Garnish with the lime wheel and serve.

Swiss & Sour

3 ice cubes, cracked
1 dash orange bitters
1 measure gin
½ measure dry vermouth
¼ measure kirsch
lemon rind
½ strawberry and lemon
 slice, to garnish

Alberto Giacometti's distinctive elongated and fragile figures are some of the most instantly recognizable sculptures in modern art. This cocktail is inspired by the life of the Swiss artist, who grew up in an Italian-speaking village in the Alps, and went on to spend most of his adult life working from a basement studio in Paris. Kirsch is an unsweetened clear liqueur distilled from Morello cherries and cherry stones that is often used in Swiss desserts and drinks, and the delicate glass mimics Giacometti's elongated human forms.

Put the cracked ice into a mixing glass, then add the bitters, gin, vermouth and kirsch. Stir well and strain into a martini glass. Squeeze the zest from the lemon rind over the surface of the cocktail, and garnish the rim of the glass with the strawberry half and lemon slice.

Tequila Sundowner

ice cubes
2 measures tequila
4 measures fresh
 orange juice
2 teaspoons grenadine
orange slice, to garnish

Olafur Eliasson's *The Weather Project*, displayed in Tate Modern's cavernous Turbine Hall in 2003, was a dazzlingly immersive work of modern art. This giant installation created the illusion of a luminous setting sun within the hall itself and prompted viewers to engage with how they perceive and experience the physical world around them. The Tequila Sunrise is named for its gradations in colour, created as the grenadine sinks down the glass, mimicking the appearance of the sun rising. Despite the name, it's far better drunk as a sundowner. Mix one up for yourself and feel the glow.

Half-fill a cocktail shaker with ice cubes, add the tequila and orange juice and shake until a frost forms on the outside of the shaker. Strain into a highball glass filled with ice cubes. Slowly pour in the grenadine and allow it to settle. Garnish with the orange slice.

Snakecharmer

4–5 ice cubes
1½ measures whisky
1 teaspoon fresh lemon juice
1 teaspoon sugar syrup
 (see page 23)
1 egg white
a few drops of Pernod

Robert Mapplethorpe was an American photographer best known for his powerful black-and-white portraits and exploration of controversial subject matter in large-scale, stylized images. His arresting photographs simultaneously challenge the viewer while presenting them with images of classical beauty. He was particularly fascinated by characters and symbols of debauchery. This classic Rattlesnake is inspired by Mapplethorpe's 1981 work, *Snakeman*, which features a beautiful man entwined by a live snake, wearing the mask of a satyr or devil, reminiscent of ancient Greek sculpture. Tangy, sweet and sour, with the right boozy bite, it will make you sit up and take notice.

Put all the ingredients into a cocktail shaker and shake extremely well, until a frost forms on the outside of the shaker. Strain into a coupe glass and serve.

Cut-out Colada

1 fresh whole pineapple,
 to serve (optional)
4 measures crushed ice
2 measures white or
 dark rum
2 teaspoons fresh lime juice
2 measures coconut cream
2 measures fresh
 pineapple juice
1 scoop vanilla ice cream
maraschino cherry,
 to garnish

In his late seventies, when bad health prevented him from painting, Henri Matisse began to cut into painted paper with scissors. Pinned in place, tropical lagoons, lush gardens and electric-blue nudes swirled around every wall of his house. The Piña Colada is a drink made for fun. Carving into a pineapple, you can create your own cut-out masterpiece in which to serve this exotic delight. You could even 'cut out' the rum for a non-alcoholic, but equally delicious, cocktail.

If using the pineapple, cut off the top and, with a sharp knife or pineapple corer, scoop out the centre. Put the crushed ice into a blender. Add the rum, lime juice, coconut cream, pineapple juice and ice cream and blend on high speed for 20–30 seconds. Pour into the hollowed-out pineapple (or a hurricane glass), garnish with the maraschino cherry and serve with a straw.

Sonia De-Lychee

ice cubes
1 ½ measures gin
½ measure lychee liqueur
1 measure lychee purée
1 measure fresh lemon juice
½ measure sugar syrup (see
 page 23)
soda water, to top up
fresh lychee in its shell,
 to garnish

This lychee cocktail honours the Orphist artist Sonia Delaunay, whose vivid colour combinations and geometric shapes graced paintings, textiles, clothes, books and posters. Despite being fluent in four languages, Delaunay was interested in the utopian possibility of a pictorial language, borderless and transnational. Her influences were myriad: on trips to the Louvre she favoured the collections of Egyptian jewellery, Assyrian sculpture and the arts of Mesopotamia. The lychee is a Chinese fruit, giving this cocktail an international edge. With its interesting sour bite, it tastes rather like a strawberry mixed with watermelon and grapes.

Half-fill a cocktail shaker and fill a highball glass with ice cubes. Add the gin, lychee liqueur and purée, lemon juice and syrup to the shaker and shake until a frost forms on the outside of the shaker. Strain over the ice in the glass. Stir and top up with soda water, and garnish with the lychee.

Flash of a Silk Stocking

4–5 ice cubes
¾ measure tequila
¾ measure white crème de cacao
4 measures single cream
2 teaspoons grenadine

Henri de Toulouse-Lautrec immersed himself in the colourful and dangerous underworld of Montmartre, Paris. The district's nightlife is memorialized by his iconic poster series for the Moulin Rouge. Portraying vivacious can-can dancers and cabaret performers, along with seedy top-hatted patrons and other denizens, Toulouse-Lautrec's work both exposed and reveled in the debauchery of the *fin-de-siècle* bars and cabarets that the artist and his peers frequented. The Silk Stocking cocktail, on which this drink is based, is named for its pastel-pink colour, a hue synonymous with dancers' pumps and stockings.

Put the ice cubes into a cocktail shaker. Add the remaining ingredients and shake until a frost forms on the outside of the shaker. Strain into a chilled Martini glass and serve.

G & G

ice cubes
2 measures gin
1 tablespoon fresh
 lemon juice
ginger ale, to top up
lemon wedge, to garnish

Gilbert Prousch and George Passmore make up the collaborative art duo Gilbert & George. They are known for their highly formal appearance and anti-elitist approach to art in a variety of media. They married in 2008 and can often be seen walking together through their East London neighbourhood. Gin and tonic became their drink of choice in 1971. In 1972 they produced a piece of video art entitled *Gordon's Makes Us Drunk* in which they sat at a table getting drunk to a soundtrack of Elgar and Grieg. In honour of the inseparable duo, this Gin Buck combines gin with ginger ale for a twist on the classic G & T.

Fill a highball glass with ice cubes. Pour the gin and lemon juice over the ice, stir gently, then top up with ginger ale. Garnish with the lemon wedge and serve.

The Bellini

½ ripe white peach
2 teaspoons sugar syrup
(see page 23)
5 measures chilled
prosecco

The Bellini, a sublime combination of fresh peach juice and prosecco and an instant masterpiece of mixology, was invented by Giuseppe Cipriani, the founder of Harry's Bar in Venice. He named the drink the Bellini because its unique shade of pink reminded him of the tunic of a saint in a painting by the 15th-century Venetian artist Giovanni Bellini. Bellini's superior use of oil paints to convey glowing light and colour made him one of the key figures of Italian Renaissance art. A Bellini made with pomegranate juice becomes a similarly artistically named Tintoretto.

Put the peach and sugar syrup into a blender and blend until smooth. Strain into a champagne flute, top up with the prosecco and serve.

Spotted Slipper

4–5 ice cubes
1 measure Midori
1 measure Cointreau
1 measure lemon juice
maraschino cherry or
 melon ball, to garnish

Dots dominate the work of the contemporary Japanese artist Yayoi Kusama – for her the dot is everything, representing the world, the cosmos and the very particles that make us human. This cocktail to celebrate her unique vision – better known as the Japanese Slipper – uses the melon liqueur Midori, with its brilliant green hue. Sweet and sour and luminous, it should be garnished with the dot of a bright red cherry or a perfect ball of melon to give it the Kusama touch.

Put the ice into a cocktail shaker, add the Midori, Cointreau and lemon juice and shake until a frost forms on the outside of the shaker. Strain into a chilled Martini glass and garnish with the maraschino cherry or melon ball to serve.

Brandy Hepworth

cracked ice
1 measure brandy
1 measure dark crème
 de cacao
1 measure single cream
grated nutmeg, to garnish

English sculptor Dame Barbara Hepworth was dedicated to the craft of hand-carving. Working directly into pieces rather than modelling them, her abstract sculptures are sinuous and organic in shape. She used wood, stone and bronze, but it is her harmonious white marble sculptures – or 'forms', as she called them – that are the inspiration behind this cocktail. A Brandy Alexander, mixed with equal proportions of brandy, cream and crème de cacao, serves up a perfectly balanced drink that is the colour of creamy marble.

Half-fill a cocktail shaker with cracked ice, add the brandy, crème de cacao and single cream and shake until a frost forms on the outside of the shaker. Strain into a chilled Martini glass or coupe, garnish with a sprinkling of grated nutmeg and serve.

Gerhard Snifter

1 measure Cognac
1 measure Bénédictine

One of the signature effects in Gerhard Richter's paintings is the 'blur'. Using a squeegee, he rubs and scrapes paint in large bands across canvases, creating a blurring of one area of colour into another. The viewer has the feeling of looking at an out-of-focus image that lies tantalizingly beyond decipherment. A brandy snifter or balloon glass is ideal for 'blurring'. As your palms warm the drink in the bowl of the glass, the aromas rise and blend yet are contained, allowing them to accumulate at the rim to be enjoyed before you drink. A simple blend is best – here the classic combination of brandy and Bénédictine is ideal.

Combine the Cognac and Bénédictine in a brandy snifter or balloon glass, stir and serve.

Wet Your Whistler

4–5 ice cubes
½ measure dry gin
½ measure apricot brandy
½ measure Cointreau
¼ measure Galliano
¼ measure fresh lemon juice
maraschino cherry,
 to garnish

'Nocturne' was the term favoured by the American artist James Whistler to describe works depicting evocative low evening light, though it has now come to mean any painting of a night scene. It is also a musical term referring to contemplative piano compositions and Whistler particularly liked to use it as part of the title of paintings with a 'dreamy, pensive mood'. Inspired by his numerous tranquil riverside *Nocturne* paintings, this Moon River cocktail makes the perfect drink for a moonlit evening.

Put the ice cubes into a mixing glass. Pour over the ice the gin, brandy, Cointreau, Galliano and lemon juice, stir, then strain into a large chilled Martini glass. Garnish with the maraschino cherry.

Monet Dubonnet

1 slice each of lemon,
 orange and cucumber
2 measures Dubonnet
1 measure apple juice
4–5 ice cubes
ginger ale, to top up
extra cucumber slices
 and sliced strawberries,
 to garnish

Claude Monet spent many years capturing the shifting reflections of clouds and light on his lily ponds at Giverny, creating about 250 oil paintings on the same theme. The dreamy colourscapes of his *Water Lilies* series perfectly evoke a summer's day in a French country garden. Dubonnet is a classic refreshing French apéritif, blended from red wine, herbs and spices. Here, it is used to give us a Gallic twist on the ultimate summer cocktail, the Pimm's Cup.

Gently muddle the lemon, orange and cucumber slices in a mixing glass. Add the Dubonnet, apple juice and ice cubes and gently stir. Strain into a martini glass, top up with ginger ale and garnish with more cucumber and strawberry slices to serve.

Rembrandy Crusta

lemon wedge
caster sugar
ice cubes
2 measures brandy
½ measure orange Curaçao
½ measure maraschino
 liqueur
1 measure fresh lemon juice
3 dashes Angostura bitters
large lemon rind spiral,
 to garnish

The Brandy Crusta was invented in 1840 in New Orleans and is said to be the grandfather of a host of classic cocktails, including the Sidecar. This recipe is a twist on the old classic, in honour of one of the great-grandfathers of art, Rembrandt van Rijn. On seeing Rembrandt's *The Jewish Bride* (1665), Van Gogh said, 'I should be happy to give ten years of my life if I could go on sitting here in front of this picture for a fortnight, with only a crust of dry bread for food.' In honour of the Dutch Master, elevate that crust to one of sweetness, with the sugar-frosted glass of this vintage drink.

Moisten the rim of a chilled Nick & Nora glass with the lemon wedge, thickly frost with the sugar and leave to dry. Half-fill a cocktail shaker with ice cubes, add the brandy, Curaçao, maraschino liqueur, lemon juice and bitters and shake until a frost forms on the shaker. Strain into the glass. Wind the lemon rind spiral round the inner rim of the glass and serve.

Op Art Original

3 measures crushed ice
2 measures gold tequila
2 teaspoons ginger syrup
1 measure guava juice
1 measure fresh lime juice
grated lime rind, to garnish

Op Art emerged in the 1960s and used lines, geometric shapes and eye-popping colour to create psychedelic artworks that fooled the eye into the illusion of movement. Bridget Riley's original and mind-bending works are the perfect example of this technique – with seemingly simple lines and dots, she employed sophisticated manipulations of colour and placement to make her two-dimensional paintings seem to come alive. Based on the Pale Original, this cocktail is anything but two-dimensional – it's a truly tongue-twisting combination of tequila, guava, ginger and tangy lime.

Put the crushed ice into a blender, add the tequila, ginger syrup, guava juice and lime juice and blend on high speed until slushy. Pour into a large Margarita glass, garnish with grated lime rind and serve.

Shark Bite

4–5 ice cubes
2 measures silver tequila
½ measure triple sec
½ measure blue Curaçao
1 measure fresh lime juice
½ measure grenadine

Much of Damien Hirst's work is preoccupied with mortality and death, and it was the iconic sculptures in his *Natural History* series that really caught the public imagination in the early 1990s, including *The Physical Impossibility of Death in the Mind of Someone Living* (1991), in which he presented a 14-foot tiger shark suspended in formaldehyde. His silent shark seems to defy death, locked into a permanent biting lunge in its blue-green tank. Inspired by Hirst's eerie vision, try this twist on the Shark Bite with a Blue Margarita base – the grenadine represents blood in the water, but it won't bite back.

Put the ice cubes into a cocktail shaker, add the tequila, triple sec, Curaçao and lime juice and shake until a frost forms on the outside of the shaker. Strain into a chilled Margarita glass, then slowly drip the grenadine into the drink and serve.

Piña Pissarro

½ lime
2 measures pineapple juice
1 measure white rum
1 teaspoon sugar
dry ginger ale, to top up
lime slice, to garnish

The influential Impressionist artist Camille Pissarro grew up on the lush tropical island of St Thomas in what was then the Danish West Indies. Perhaps it was the azure sea and trade winds of his Caribbean roots that informed his habit of painting outdoors and his preference for natural settings – he would sit outside for the duration of each piece of work, often finishing paintings in just one sitting. The rum and pineapple in this classic Havana Beach cocktail offer up some of the natural tropical flavour of Pissarro's earliest works.

Cut the lime into 4 pieces and put in a food processor or blender with the pineapple juice, rum and sugar. Blend until smooth. Pour into a hurricane glass and top up with dry ginger ale. Garnish with a lime slice.

The Klimt Clinch

4–5 ice cubes
1½ measures apple brandy
¾ measure yellow chartreuse
¾ measure Bénédictine
2 dashes Angostura bitters
maraschino cherry,
 to garnish

A founding member of the Vienna Secession, the Symbolist artist Gustav Klimt is now best known for his painting *The Kiss* (1907–8). It was produced during the height of his 'Golden Period' and featured sumptuous gold-leaf appliqué. Suggestive of all that decadent gold, this Klimt Clinch is inspired by the Widow's Kiss cocktail. It has a delicious amber hue and its brandy base will envelop you in a glowing cloak of warmth, reminiscent of that famous romantic embrace.

Combine the ice, brandy, chartreuse, Bénédictine and bitters in a mixing glass, stir and then strain into a chilled coupe glass. Garnish with the maraschino cherry and serve.

Schiele's Knees

3 teaspoons honey
2 measures gin
1 measure fresh lemon juice
¾ measure ginger liqueur
ice cubes
lemon rind twist, to garnish

Egon Schiele was a radical Austrian artist who used a distinctive drawing style to create intimate portraits. Although he was frequently dismissed as 'degenerate' during his lifetime, the honesty and daring with which he delineated the human body are today revered. His intense portraits often featured anguished, emaciated nude figures with contorted bodies and twisted limbs, knees drawn up. Inspired by his well-known and somewhat less tortured work, *Seated Woman with Bent Knee* (1917), which featured his wife, Edith, this is a twist on the Bee's Knees cocktail. The sweetness of the honey is tempered by a sour sting in the tail for more intensity.

Combine the honey and gin in the mixing cup of a cocktail shaker and stir until the honey has dissolved. Add the lemon juice, ginger liqueur and ice cubes and shake until a frost forms on the shaker. Strain into a chilled coupe glass and serve garnished with a twist of lemon.

Long Tall Modigliani

ice cubes
3 measures prosecco
2 measures Aperol
club soda or sparkling
 water, to top up
orange wedge, to garnish

Amedeo Modigliani was an Italian painter and sculptor who worked mainly in France. He is best known for his distinctive modern but rather melancholy style, characterized by elongated faces and necks, almond-shaped eyes and sloping shoulders. His ideal of beauty was heavily inspired by the 'primitive' arts, such as African masks, Khmer carvings and the sculpture of ancient Egypt and Rome. The best cure for a 'long face' is a long cool drink and this refreshing Aperol spritz, hailing from Northern Italy where Modigliani spent his youth, makes the ideal candidate.

Fill a wine glass or tumbler with ice cubes, pour in the liquid ingredients and lightly stir. Garnish the glass with a wedge of orange to serve.

Negrona Lisa

ice cubes
1 measure gin
1 measure Campari
1 measure red vermouth
soda water, to top up
 (optional)
orange spiral, to garnish

Her teasing smile and bewitching gaze have captivated artists and admirers alike for centuries. Leonardo da Vinci's enigmatic *Mona Lisa* (1503–06) is possibly the most famous painting in the world, and also the most mysterious. Few are confident of who the sitter is nor how the work came to be. What is universally agreed however is that this is a masterpiece in perfection: atmospheric, monumental and in perfect equilibrium. A quiet classic that was invented in Florence, the birthplace of Leonardo, the Negroni is all about balance, each ingredient an equal part. Cocktail cognoscenti delight in its delicious bittersweet sophistication.

Put 4-5 ice cubes into a mixing glass and fill a rocks glass with ice cubes. Add the gin, Campari and vermouth to the mixing glass, stir briefly to mix and strain over the ice in the rocks glass. Top up with soda water, if you like. Garnish with an orange spiral and serve.

Same Again, Andy?

ice cubes

2 measures vodka

1 dash fresh lemon juice

Worcestershire sauce,
 to taste

tomato juice, to top up

½ teaspoon cayenne
 pepper

salt and pepper

celery stalk, to garnish

Andy Warhol's obsession with the repeating image underpins one of Pop Art's most enduring motifs and his *Campbell's Soup Cans* (1962) was his own favourite work. It's only a small leap from tomato soup to tomato juice, so for a Warhol-inspired cocktail, it has to be the Bloody Mary – one of the cocktail world's Superstars. That bright pop of red and the unapologetic shock of green celery would surely have appealed to the king of bright colours. There are many ways to vary a Bloody Mary, with more or less spice (some like it hot!), but why not make like Andy and just have the same again.

Put some ice cubes into a highball glass. Pour over the vodka and lemon juice, add Worcestershire sauce to taste and top up with tomato juice. Add the cayenne pepper and season to taste with salt and pepper. Stir to chill. Garnish with a celery stalk and serve.

Index by Spirit

An Hachette UK Company
www.hachette.co.uk

First published in Great Britain in 2019
by ILEX, an imprint of
Octopus Publishing Group Ltd
Carmelite House
50 Victoria Embankment
London EC4Y 0DZ
www.octopusbooks.co.uk

Copyright © Octopus Publishing Group
Ltd 2019

Distributed in the US by
Hachette Book Group
1290 Avenue of the Americas
4th and 5th Floors
New York, NY 10104
Distributed in Canada by
Canadian Manda Group
664 Annette St.
Toronto, Ontario, Canada M6S 2C8

ISBN 978-1-78157-656-4

A CIP catalogue record for this book is
available from the British Library.

Printed and bound in China

10 9 8 7 6 5 4 3 2 1

Publisher Alison Starling
Editorial Director Zena Alkayat
Managing Editor Rachel Silverlight
Commissioning Editor Ellie Corbett
Contributing Editor Emily Preece-Morrison
Art Director Ben Gardiner
Illustrator Charlotte Trounce
Production Manager Lisa Pinnell

Salvatore Calabrese has asserted his right
under the Copyright, Designs and Patents
Act 1988 to be identified as the author of
the foreword of this work

Some of this material previously appeared
in *The Classic Cocktail Bible*, published
by Spruce.

Margarita Gin } 1½ oz
 Cointreau } 1 oz
Margarita → Lime Juice } ¾ oz

Lime a toum or glass rim
& dip in salt.

 Tequila } 2 oz
 Lime } 1 oz
 Cointreau } 1 oz

Brandy Alexander Cognac 1½ oz
 Crème de Cacao 1 oz
 Cream 1 oz
 Garnish w. Nutmeg.